KRISHN

A HINDU VISION OF GOD

Scenes from the Life of Krishna illustrated in Orissan and other Eastern Indian Manuscripts in the British Library

Jeremiah P. Losty

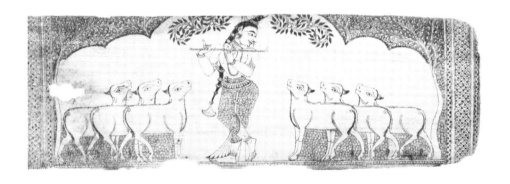

Oṃ! namo Kṛṣṇāya Govindāya

THE BRITISH LIBRARY

British Library Booklets

It is the aim of this series of booklets to
introduce the British Library to the general
public by drawing attention to aspects of its
collections which are of interest to the layman as
well as the scholar. Many of the items mentioned
and illustrated in the booklets are frequently on
exhibition in the British Library's exhibition
galleries in the British Museum building in Great
Russell Street, London, WC1.

Acknowledgements

Reproduction of figure no. 9 is made by courtesy
of the Victoria and Albert Museum.

© 1980 The British Library Board
Published by the British Library,
Great Russell Street, London, WC1B 3DG

🗏🗏 British Library Cataloguing in Publication Data
Losty, Jeremiah P
 Krishna.
 1. Krishna 2. Manuscripts, India
 I. Title II. British Library. *Reference Division.*
 294.5′1′3 BL1220

ISBN 0 904654 51 6
Designed by Peter Campbell
Set in Monophoto Ehrhardt
Printed in Great Britain by
Fletcher & Son Ltd, Norwich

KRISHNA

Introduction

Krishna, the stern upholder of duty as the spiritual teacher of mankind in the *Bhagavad Gītā*, Hinduism's most famous scripture, is also the most romantic and sensuous of lovers. The child and youth whose pranks endear him to the cowherds of Brindaban is also God, the supreme lord of the universe. In the totality of the conception of divinity that is Krishna, various traditions of Indian belief and worship have been synthesised in a manner whose end-product presents no difficulty to the Indian mind, but which to the European perhaps needs disentangling. This has been done many times before by writers anxious to explain Hinduism or Krishna to the west, or to present their conception of how the various pieces of the whole fit together, but perhaps it needs to be stressed here at the outset how presumptuous is this procedure.

We are dealing here not with the mythology of a dead civilisation, but with the fundamental tenets of a living faith embraced by 500 million people. Any brief analysis of a living faith into its constituent parts as a means of explaining that faith to outsiders must of necessity fail, because it analyses only the outward forms, and not the spiritual insights which constructed the religion in the first place, the 'how' and not the 'why'. The reader should bear this in mind, for he will not find Krishna 'explained' in the following pages which offer rather some observations on aspects of Hindu belief concerning Krishna, and their reflection in the literature and art of Orissa, a remote and lovely part of India south-west of Calcutta, and one of the most artistically interesting. The illustrations in this book are taken mainly from three of the most beautiful manuscripts from Orissa in the British Library's collections, together with a few other Eastern Indian manuscripts. These present a very different aspect of Indian painting from the far better known Mughal and Rajput schools, but one which is no less interesting for those drawn to Indian art.

Hindu Scriptures

The history of Hinduism until quite modern times is best studied through the texts of the religion, but the revealed texts of Hinduism cover a huge time-span (roughly 1500 BC–AD 1000) and are extremely numerous. The first period of revelation, which comes to an end about 500 BC, is called the Vedic period, after the sacred poems revealed to seers directly, the Vedas, and their associated metaphysical and sacrificial literature, for at this period of Indian belief the gods are nature gods – of fire, thunder, water – and the cult is sacrificial. In these texts Krishna is only briefly mentioned.

In contrast to the Vedic literature which is called *Śruti*, or 'hearing', the divine word heard and passed on by seers, the rest of the revealed Hindu texts are called *Smṛti* or 'remembering', divinely inspired, but not the direct word of God. This corpus of literature is not immutable and eternal as are the Vedas, but subject to expansion and interpolation as seers are inspired by divine influence. The major texts begin with the two great Sanskrit epics the *Rāmāyaṇa* and *Mahābhārata*, which were composed and expanded in the millennium beginning 500 BC, while the rest, chiefly a class of works called Puranas, were mostly in existence by AD 1000, but were still subject to interpolation for many centuries thereafter and, in theory, could still be added to even now. A *Purāṇa*, meaning anything ancient, is a collection of stories about the gods and the world, mythology, cosmology, etc., and usually devoted to the glorification of one of the gods. These texts, being of divine inspiration, are not dated, nor given to individual authors, and there is very little external evidence by which to date them, but after two centuries of critical writings there is now a general consensus about the relative order of the texts and some sense of absolute chronology too. But an approximately fixed date for a text is valid only for the kernel of that text and not for the interpolations; and this is the problem which bedevils any history of Hinduism,

for it is the interpolations in the epics which declare the divinity of Krishna, not the most ancient texts themselves. The kernels of the epics, into which we need not go in detail, are in the *Mahābhārata*, an internecine family feud, one party to which is helped by Krishna, and in the *Rāmāyaṇa*, the wrongful exile of Prince Rama and the recovery of his abducted wife. These ancient tales must have been in existence by at least 500 BC, but over the next millennium were constantly added to – verses, chapters, cantos and whole volumes – until by AD 500 the epics declared that Krishna and Rama were but incarnations of God Vishnu, and through worship of Him salvation could be achieved.

Vishnu-Krishna as Supreme Being

The epic period is of critical importance in the development of Hinduism. At its beginning, the religion of India was a polytheistic nature worship in which the gods were extolled and appeased by sacrifice, burnt offerings in the sacred fire. Philosophical speculation however had in the Upanishads already reached the position that there was but one Supreme Being, an impersonal World-Spirit, Brahman, and that men, the world and the gods were but transient shadows, forever doomed to a cycle of rebirth dependent on the law of *karma*, viz. that actions in one life for good or ill had inevitable consequences in the next. Until one not only knew but experienced in the intensest spiritual absorption the identity of the individual soul with Brahman, an experience possible only to those who had passed beyond the need for action and the opposition of good and evil through which *karma* clings to the soul, there was no escape from this world, and the soul was doomed to be born again and again at levels of existence (divine, human or animal) determined by one's conduct in past lives. This position of the classical Vedanta, though of great beauty and subtlety, is also a stern and chilling doctrine for the toiling masses who have neither time nor inclination for meditation and metaphysical speculation. For them came hope in the

writings of an unknown genius who synthesised the various paths open for release from this world and added a new one: through *bhakti*, intense devotion to the all-knowing, all-loving, merciful God, the cycle could be broken and release obtained. This text is the *Bhagavad Gītā*, the Song of the Lord, a sermon delivered by Krishna on the great battlefield of Kurukshetra between the armies of the opposing cousins in the epic *Mahābhārata*, and in it Krishna declares himself to be the all-loving God, incarnated from age to age to rescue mankind from untoward perils. The age of the *Bhagavad Gītā* is controversial, as is whether it is the work of one genius, or whether it is the effort of various sages spread over several centuries – probably from the second century BC to the second century AD. But its cardinal doctrine, that of devotion to a personal God through Whom comes release from transmigration, sets the tone of most Hindu religious writings up to the present day.

God to Hindus is not a jealous and prescriptive figure, demanding adoration of Him and none other; the Hindu conception of the divine allows divinity on several levels. In the Indian countryside innumerable local nature- and folk-divinities abound, gods of stream or well, of trees and forest, who may be worshipped for benefits, or for propitiation. In the heaven of Brahma on top of Mount Meru live the main divinities of the Hindu pantheon, recognised and worshipped by all Hindus – Brahma the Creator, Vishnu the Preserver and Shiva the Destroyer. They have each their individual consort – Sarasvati, goddess of learning, Lakshmi, goddess of wealth and Parvati, a complex lady, Shiva's consort and mother of Ganapati, the elephant-headed god, and of Kubera, god of war. These divinities, who appear as powerful figures in the *Śruti* period of Hindu literature, allied with the remnants of the pantheon of the Vedic period of 2,000 years earlier – Indra god of thunder, Surya the sun-god, etc. – form the Olympus of India, divinities whom all Hindus recognise as divine, but who do not in any sense constitute the Supreme Being, but are as subject to the laws of *karma* and

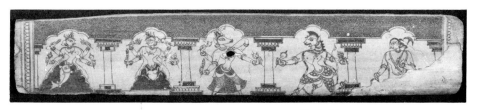
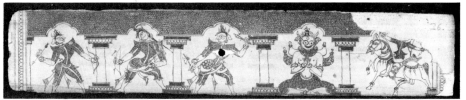

1. *The ten avatars of Vishnu. Orissa, 18th cent. Or. 13719, ff. 25b, 26a.*

transmigration as are all other living beings. Indeed, every migrating soul eventually reaches the rank of Brahma (who is of course a different being from the impersonal World-Spirit, Brahman).

But Hinduism is not, contrary to popular western belief, a polytheistic religion in which worship is offered to a multiplicity of gods indiscriminately. Like the other great civilisations of antiquity, India experienced the religious and philosophical upheavals which transformed polytheistic into monotheistic societies. Where the western religions jettisoned the old gods, who could survive only in the guise of saints, India retained her ancient divinities in the same heaven. One of them was elevated to be the Supreme Being, the personalised Brahman of the Upanishads, but whether Vishnu or Shiva or, more unusually, one of the other divinities, was dependent on the individual choice or caste or sect affiliation of the worshipper. To this supreme God, all the other gods are subordinate, and are indeed considered to be but manifestations of Him.

The elevation into Supreme Being of one or other of the gods is the usual purpose of the interpolations in the epics, and of the Puranas. Of the eighteen major Puranas, the majority are devoted to the elevation of Vishnu to this status. This series of Puranas culminates in the *Bhāgavata Purāṇa*, composed probably towards the end of the first millennium AD, which is the classic text of the Vaishnava tradition extolling Vishnu as Supreme Lord of

the Universe, and recounts in detail all His many incarnations in this world. All Hindus believe that the Vishnu of Brahma's heaven is the Preserver of the World, and is incarnated from age to age to save it from great peril, but the *Bhāgavata* claims this for Vishnu as Supreme Being. These incarnations are known as avatars, of which there are ten major ones (fig. 1). These are: (1) Matsya, the Fish, who saved Manu the progenitor of mankind from destruction by the Great Flood; (2) Kurma, the Tortoise, who acted as the pivot underneath Mt. Mandara which was the churning stick used by the gods to recover miraculous objects and divinities lost in the Ocean in the Flood; (3) Varaha, the Boar, who recovered the Earth from the bottom of the Ocean, whither she had been dragged by a demon; (4) Narasimha, the Man-Lion, who slew the great demon Hiranyakashipu; (5) Vamana, the Dwarf, who delivered the Three Worlds from the dominion of Bali the demon-king; (6) Parashurama, Rama with the Axe, who saved the Brahmins from the arrogant dominion of the Kshatriyas or warrior-caste; (7) Rama, the hero of the *Rāmāyaṇa*, who delivered the world from the demon Ravana; (8) Balarama, elder brother of Krishna, who together rid the world of the evil Kamsa; (9) the Buddha, whom the Brahmins incorporated quite late into the Hindu tradition as an avatar of Vishnu incarnated to lead evil men to despise the Vedas and the caste system and so destroy themselves; and (10) Kalki, the future ava-

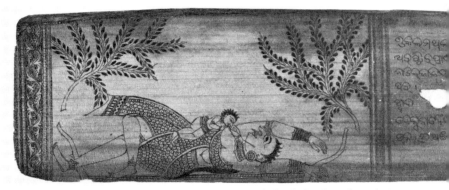

2. Krishna sucking the life out of Putana (left), and dancing on the head of Kaliya, the snake-king (right). Orissa, 17th cent. Or. 11612, f. 3a.

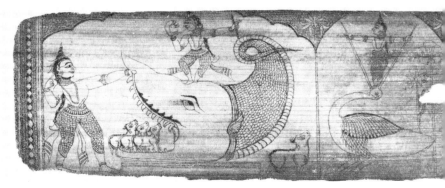

3. Krishna slaying the snake-, crane-, horse- and bull-demons. Orissa, 17th cent. Or. 11612, f. 3b.

tar, who will come on a white horse at the end of this current age to destroy the wicked and reward the righteous. As an avatar represents but a portion of the divine essence of Vishnu, it is Balarama who is accounted the eighth avatar in the final authoritative listing and not Krishna, who is Vishnu Himself in all His divine splendour according to the *Bhāgavata Purāṇa*.

Krishna's Life

The tenth canto of the *Bhāgavata Purāṇa* of *ca*. AD 900 presents the fullest and most authoritative account of the early life of Krishna. The tale runs as follows. In the city of Mathura, in Braj (on the Jumna river some 70 miles south-east of Delhi), there ruled the wicked king Kamsa, who it was foretold would be slain by a son of his cousin, Devaki, who was married to

Vasudeva. Devaki was kept imprisoned by Kamsa, and all her children slain, but her seventh child was miraculously transferred to the womb of Rohini, the second wife of Nanda, a rich cowherd, and was born as Balarama. Devaki's eighth child was born to her in prison, and being very dark skinned He was called Krishna, the Dark one. (In Indian art, He is usually depicted as blue or black.) The gods intervened to protect the child – they cast the palace into sleep and unfastened all the doors, and Vasudeva was able to take the child across the Jumna and substitute Him for a female infant just born to Yashoda, Nanda's first wife. Vasudeva returned to Mathura with the infant girl, and Kamsa, discovering the trick, ordered all vigorous newborn male children to be slain. Nanda and his wives and family, including Krishna and Balarama, moved fur-

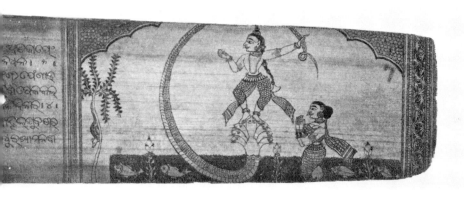

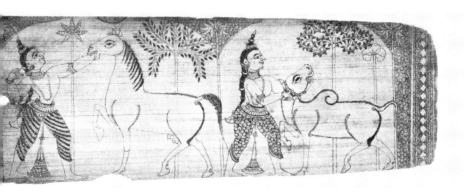

ther away from Mathura, to Gokula, and there the two brothers grew up. As they progressed, they played many childish pranks, usually connected with stealing pots of curd and butter which they loved. In time Kamsa came to know of their existence, and sent demons to destroy Krishna. The demoness Putana tried to kill Him by suckling Him with her poison, but Krishna was able to suck the life out of her first (fig. 2). Kamsa sent other demons in other animal guises to kill Krishna, but these too He was able to destroy (fig. 3): Agha the great snake, who swallowed up cows and cowherds; Baka, the crane, whom Krishna tore in two; Hayaraja, the Horse-king, strong as the wind; and the demon who assumed the form of a bull, slain by Krishna with His bare hands. The greatest of these demons was the many-headed snake-king Kaliya, who dwelt in the Jumna with his numerous wives and whose poison contaminated the waters of the river. After a great struggle, Krishna crushed him underfoot, and then to the accompaniment of music from the assembled denizens of heaven, began to dance upon the serpent's thousand hoods (fig. 2). The serpent-king's wives prayed to Krishna to spare their Lord, and Kaliya himself eventually begged for mercy. Krishna commanded him to remove himself to the sea, and free the Jumna from his pollution.

It was not only demons against whom the youthful Krishna pitted himself, thus revealing His divinity to the cowherds. It was their custom to pay worship to Indra, the god of rains who controlled the monsoon and hence fertility, with an annual feast, but Krishna persuaded them that Indra could not give them any benefits not

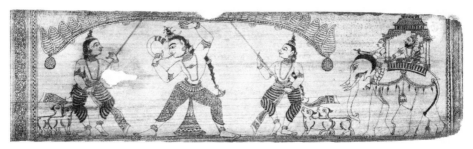

4. *Krishna lifting Mount Govardhana. Orissa, 17th cent. Or. 11612, f. 2b.*

already due to them because of their *karma*, and that it made more sense to pay homage to the mountain Govardhana, which protected their cows. This the cowherds did, arousing the wrath of Indra, who caused most terrible storms to fall upon them. The cowherds besought Krishna for protection and He with one hand lifted up the mountain for the cowherds and their families and their cattle to shelter under, and held it there for seven days (fig. 4). Indra, finally humbled, called off his storm clouds, and came to worship Krishna. Nanda and the cowherds fell to wondering what manner of youth this was.

His grace and beauty had long captivated the hearts of the gopis, the wives and daughters of the cowherds, a captivation symbolised by the music of Krishna's flute, which called to them mysteriously through the groves and across the fields of Braj (title-page). To them in a mystical communal union, Krishna revealed Himself to be God. This is called the *Rāsakrīḍa* (the Play of Love) the famous sequence from the *Bhāgavata Purāṇa* where Krishna enticed the gopis out to him at night in the groves of Brindaban, and after mercilessly testing their devotion, danced with them in a circle, by His divine power ensuring that each thought that she alone was dancing with Him (plate 1).

His youth ended, Krishna with Balarama returned to Mathura and there killed the wicked Kamsa, and became King of Mathura. From now on He behaved as a prince, contracting alliances, making state marriages, and warring with his neighbours. He was also the principal ally of the Pandava brothers in their struggle against their cousins, the Kauravas, in the family feud in the epic *Mahābhārata*. He was the special friend of one of the brothers, Arjuna, and it was to Arjuna who was hesitating before a great fight with his cousins, wondering where lay the right course in a choice which would inevitably bring disaster, that He delivered the counsel called the *Bhagavadgītā* – 'Do your duty, the duty you were born to as a warrior, but with detachment – do not will the fruits of your efforts either good or bad. By meditating on Me, by adoring Me, you will gain release from rebirth and be absorbed into Me.' Here Krishna revealed again that He was God, in the hollow of Whose hand lay all the worlds and their inhabitants – animal, human and divine. Arjuna did his duty, and the slaughter was tremendous. The Pandavas were left with the ashes of victory, and were not content with regaining the kingdom. Krishna, realising that it was time for Him to leave this world, retired to His city of Dwarka on the coast, and there engendered the destruction of all His kinsmen, before leaving His own body. He was shot in the sole of His foot, His only vulnerable spot, by a hunter, and died.

The *Bhāgavata Purāṇa* has put together for the first time in Indian literature a coherent narrative of all the events of Krishna's life, taken from diverse sources. Krishna's involvement with the Pandava brothers is an extremely ancient tale from 500 BC at the latest, while the events of his childhood and youth are much more recent in the sense that they first surface in a pan-Indian context in about AD 500. This is not to say that this part of the story is not as

ancient as the other, only that it was more localised, doubtless in Braj, until much later. Once given pan-Indian publicity, the whole story corresponded to a need in the Indian psyche at this time, which identified not only Krishna with God but the cowgirls as the souls of mankind, longing to escape the cycle of rebirth in the ultimate bliss of union with God. In Indian philosophical and poetic imagery, the bliss of union with and absorption into God is constantly compared with the bliss of sexual union. In a mass religious movement comparable to the religious turmoil of the sixth century BC, this doctrine swept across India inspiring poets to write of the soul's ecstatic union with God as the cowgirls with Krishna. The 12th-century poet Jayadeva in his Sanskrit lyric-poem *Gītagovinda*, the Song of the Cowherd, a conscious reference to the *Bhagavadgītā*, the Song of the Lord, first expressed the longing of Radha, chief of the cowgirls, for Krishna's embraces and her ecstatic raptures when achieved, and inspired countless poems on the same theme, dominating the early vernacular literature of northern India, and inspiring poets and painters ever since.

Orissa – History and Culture

The province of Orissa on the coast of the Bay of Bengal, intermediate between north and south India, mingles the cultures of both to form its own highly individual one. Anything Orissan is instantly recognisable as such, whether it be a sculpture, a temple, a painting or a manuscript, or its literature, script or dance-style. Orissa developed its artistic forms in isolation for much of its history, for between the collapse of the Mauryan empire in the second century BC and 1568, it managed for the most part to maintain a precarious independent existence, and at times during this long period was one of the most important powers in the Indian system. The greatest period of Orissan art was between the seventh and 13th centuries when the magnificent series of temples at Bhubaneshwar, Puri and Konarak were built. Around the sacred lake at Bhubaneshwar (plate VIII) lie hundreds of ancient temples dated between the seventh

and 13th centuries, whose sculptures and carvings are at once the most vigorous and elegant of their periods. The great temple of Jagannatha at Puri, one of the most celebrated shrines in India (plate VII), was begun *ca.* 1135 by King Anantavarman Chodaganga (fig. 5) whose reign marked the beginning of four centuries of imperial power for Orissa. The Temple of the Sun on the sea-shore at Konarak, built by King Narasimha I in the 13th century, marks the culmination of Orissan art, and its final great masterpiece. Drastically affected by the Turkish conquest of north India, even though not yet subject to it, a conquest which dried up the springs of the Hindu genius for centuries in north India, monumental Orissan art thereafter declined into sterile repetition.

As in the rest of Aryan India, the earliest religious survivals in Orissa are Buddhist and Jain. But from the seventh century onwards, there is a sudden surge of activity in temple building and image-making among the Hindus, especially at Bhubaneshwar, the great centre of Shiva worship in Orissa. This is a development paralleled to some extent all over India. The Brahmanical religion based on the sacrificial ritual which the Buddha had so ruthlessly assaulted underwent profound changes during the many centuries of the dominance of Buddhism in India. As we have seen, a polytheistic religion offering sacrifice to many nature-gods was transformed into a monotheistic religion offering salvation through loving devotion to a personalised God. This development demanded the making of images and temples in which to house the images for worship.

All but one of the temples of Bhubaneshwar is dedicated to Shiva (plate VIII). It appears that Orissa as a whole was a land in which Shaivism was the dominant sect during this early Hindu period, and in many instances Buddhist shrines were taken over for the worship of Shiva. Vishnu at this time was not much worshipped. The great shrine at Puri is a witness to the intimate connection between all three systems. Originally perhaps a Buddhist shrine, it was taken over by the Shaivas, before finally becoming one of the great

Vaishnava shrines of India. The image of Jagannatha ('Lord of the World') worshipped therein is, uniquely in all India, not a recognisably human form of Vishnu-Krishna, but a solid block of wood greatly resembling the *linga* or phallic image which is the universal icon of Shiva worship, while from the medieval period on it is this image which represents the ninth incarnation of Vishnu, the Buddha (fig. 1). Anantavarman Chodaganga seems to have tried to introduce the worship of Vishnu into a country hitherto solidly Shaiva. There is good reason to believe that this was for political reasons, to counterbalance the power of the Shaiva priests of Bhubaneshwar and to identify royal power with Jagannatha, a god who was becoming the symbol of the Oriya people and Oriya culture. But it was the visit to Puri of the great Bengal mystic and reformer, Chaitanya, which really established the worship of Krishna in Orissa.

Chaitanya (1485–1533) was one of the last and greatest of the Vaishnava *bhaktas* or mystical devotees. Born in an orthodox Brahman family at Nadia, a famous university town in Bengal, and destined to a life of scholarship, he conceived an intense personal devotion to Krishna and his consort Radha, and at the age of twenty-four he became a *sannyasi* or wandering ascetic. He spent some years wandering through India singing and preaching his ecstatic devotion to Krishna, but spent most of the rest of his life in Puri, devoting himself to Jagannatha. He attracted immense numbers of followers as well as a group of ardent disciples who composed the detailed devotional and theological writings of the sect, though he himself wrote nothing and achieved conversions through his intense personal magnetism. Through music and dance and songs of devotion to Krishna and Radha, His consort, the chief of the gopis, he was able to move immense numbers of people to ecstatic devotional raptures and convert them to Vaishnavism, and to establish Puri as one of the greatest pilgrimage centres for the whole of India, which it has remained to this day. His influence on vernacular literature was also profound, as practically all the Oriya litera-

ture produced for the next few centuries has for its theme devotion to Krishna, and His love for Radha and the gopis.

Orissan Manuscripts and Manuscript Illumination

As papyrus was to Egypt and vellum to medieval Europe, so was the palm-leaf to India. This writing medium, so surprising to the European, was the staple writing material of India and much of south-east Asia for two thousand years. Only two varieties of palm were commonly used – the talipot (*Corypha umbraculifera*), and at a much later date, after its introduction from east Africa, the much coarser palmyra (*Borassus flaballifer*). The leaves were prepared first by being separated from the central rib and cut to the required shape: a long narrow rectangle, of a size often dictated by the nature of the work to be recorded, very long (up to 30 inches) for sacred texts, much smaller for works of history and literature. The leaves were then dried and boiled several times and finally rubbed to produce a light brown, flexible and smooth writing surface. A pile of such leaves was assembled and a hole bored through, usually off centre (two holes in the case of very long manuscripts, about a quarter of the way from each end). At this stage the text would be written on the leaves. Two wooden boards of the same shape were placed at the top and bottom and the whole pile then strung on a cord to produce the finished manuscript. The climate of India is not conducive to the preservation of perishable materials, but in the Jain libraries of the Rajasthan desert cities many such manuscripts have survived for a thousand years. Older ones still have been found in the cooler, upland valley of Nepal, and fragments of Indian palm-leaf manuscripts dating from as early as the second century AD have been found in Central Asia. In south India, Ceylon and south-east Asia, they were still the normal writing material in the 19th century.

There were two basic methods of writing on palm-leaves, marking a division between north and south India, the dividing

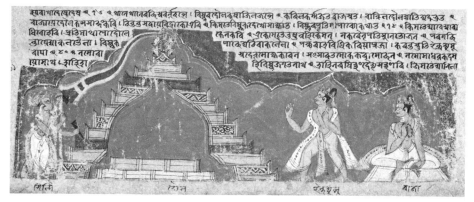

5. *The building of the temple of Jagannatha at Puri. Assam, 17th cent. Or. 13086, f. 168b.* (*16·5 × 40·5 cm*)

line being one roughly between Goa in the west and Calcutta in the east. North of this line, pen and ink were used, south of it a pointed stylus. In the north, calligraphy and the illumination of manuscripts reached a high point in the last two centuries of the Pala empire's dominion in eastern India (*ca.* 950–1150), in the great Buddhist monastic universities (fig. 6). The leaves were illustrated with miniatures in gouache of the Buddha and Buddhist divinities, while on the binding boards much larger compositions were possible. The text was written in black carbon ink in an elegant and ornamental script called *Kutila*.

By contrast, in the southern half of India, including Orissa, the normal writing tool for palm-leaves was a pointed stylus, with which the letters were incised into the leaf. The palmyra leaf favoured in the south does not, unlike the talipot leaf, absorb ink well; hence the use of the stylus. The ancient Indian word for writing, *likh*, actually means scratching, and is applicable to the earliest example of Indian writings, inscriptions on stone. However, the earliest surviving examples of writing on palm-leaves are all surface-written with pen and ink, as are the earliest extant manuscripts from southern India, dating from the 12th century. The change to a stylus seems to

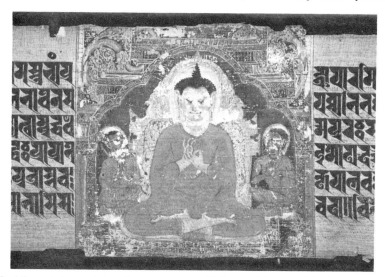

6. *The Buddha seated in a shrine. Pala, monastery of Vikramashila (east Bihar),* ca. *970. Or. 6902, f. 1b.* (*65 × 70 mm*)

7. The 14 dreams of Devananda,
showing the protruding further eye.
Jain school, W. India, 1445-6.
Or. 13700, f. 2b (110 × 75 mm)

have occurred after this, with the disruption to trade caused by the Muslim invasions and the introduction of the palmyra. Be that as it may, in Orissa the method of writing was to incise the text on to the leaves, and then, usually, smear the whole leaf with an ink compound containing lampblack. After removal of the surplus, the incised grooves were left black and legible.

The same method was used for the illustration of Orissan manuscripts. The illustrators in the manuscripts discussed here have a most detailed knowledge of the texts, and if they were not also the scribes, must have had a very strong influence on the choice of verses to illustrate and how to do it. The technique proved one in which considerable subtlety was possible despite the apparently intractable nature of the basic materials. After the basic outline was drawn in, the detail could be added. Degrees of light and dark in the line were achieved by gradations in the depth of incision, while solid dark areas called for a most precise and delicate use of cross-hatching; the deeper and more frequent the incisions the darker the result when the ink was applied. Sometimes touches of colour were added sparingly, but in some instances this was added much later. By and large, the earliest manuscripts have no colour, the ones of the 19th century too much.

Despite some scholars' claims to the contrary, it is highly unlikely that any extant illustrated manuscript from Orissa is earlier than the 17th century. However, the technical sophistication of these manuscripts indicates that this art must have been practised much earlier. The survival both in Orissan and Assamese manuscripts of features of the pre-1200 Pala school, such as depicting figures within architectural compartments or shrines (compare fig. 6 with fig. 5 and figs. 10-82 passim), argues a continuity of artistic tradition in eastern India during the early Muslim period. In a general view of eastern Indian painting, it is an accident of history that Pala Buddhist manuscripts alone have sur-

vived from the earliest period, since they were taken to Nepal by monks fleeing the Turkish onslaught, where the cooler climate, both meteorological and political, was more conducive to their preservation. No such happy accident befell the Hindu manuscripts of Bengal and Orissa which must have been produced contemporaneously with the Pala manuscripts, and they have been destroyed by a combination of war, neglect, the climate and the habit of pious Hindus of having copies made of old and faded manuscripts and of committing the old version to a sacred river. The result is a gap of three centuries in the history of painting in eastern India, about which one can only speculate.

In painting of the Pala school, there is continual tension between two styles, a classical style based ultimately on a now lost Gupta syle of flowing line and modelled contours, no doubt similar to the Ajanta school, and a medieval style of jagged and distorted line and flat colour planes. In the three centuries gap between the end of the Pala school and the middle of the 15th century, when the curtain rises again on eastern Indian painting, the classical style has been ousted and the medieval style reigns supreme. The most obvious change is the almost completed shift from displaying the human face in full frontal aspect or three-quarter profile, to a rigid adherence to full profile, one of the most dominant characteristics of Indian painting until the 19th century. The reason why this change occurred is unknown, but that it did not happen without considerable technical difficulty is obvious from the paintings of the 14th and 15th centuries from other parts of India, where a similar revolution in the human profile, though not yet carried quite so far, left one eye protruding into the air instead of disappearing behind the face (fig. 7). In the painting of the conservative Jain school of western India, this disturbing characteristic was maintained until about 1600, while in eastern India it had disappeared by the end of the 15th century. It is no longer visible in the north Bihar book covers of 1491 (fig. 8) and the Bengal covers of 1499 divided between the British and the Victoria and Albert Museums (fig. 9).

These two pairs of covers, almost contemporary, demonstrate two radically different styles, the former being linked to the early Rajput school of the 16th century, and to 17th-century Orissan manuscripts, while the latter displays an angularity of outline with sharp-pointed noses and chins, the eastern equivalent of the contemporary

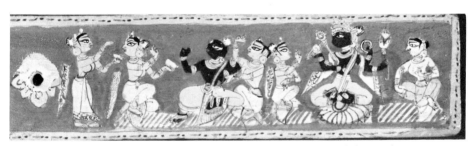

8. *Krishna with gopis. N. Bihar, 1491. Or. 13133, lower cover, detail. (5 × 36·5 cm, complete cover)*

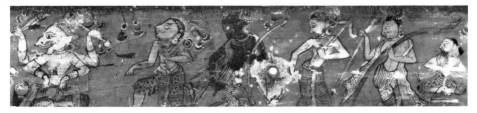

9. *Avatars of Vishnu. Detail of book cover from Bengal,* ca. *1499. (9 × 56·5 cm) Victoria and Albert Museum, I.S. 101–1955.*

western Jain school, that has almost brought us into the world of late Orissan illustrations. Although these pairs of book-covers are the sole surviving represen-tatives of their styles, it is probable that there were two such schools of manuscript illumination practised throughout eastern India at this time, officially encouraged in Hindu-ruled Orissa, but not in Muslim-ruled Bihar and Bengal except in the time of enlightened monarchs such as Husayn Shah (1493–1519). In Bengal, exposed more to artistic influences from the rest of India and the Islamic world, these me-dieval schools had disappeared by the 17th century. Not so in provincial, conservative Orissa, where even incorporation into the Mughal Empire in 1592 did little to affect her age-old culture and traditions.

The subject-matter of these illustrated manuscripts reflects the dominant theme of Oriya literature, that is to say, Vaishnava literature dealing for the most part with the life of Krishna. The illustrated texts are therefore the *Bhāgavata Purāṇa*, in Sans-krit or in the Oriya version of Jagannatha Dasa, or episodes taken from the *Bhāga-vata*, usually from the tenth canto; other Sanskrit or Oriya texts based on the *Bhāgavata*, such as the *Gītagovinda* of Jayadeva; a host of Oriya poems dealing with the same theme; and occasionally some other Vaishnava text such as the *Rāmāyaṇa*. The British Library has a collection of a dozen illustrated manu-scripts from Orissa, from which the three most beautiful are now described in detail. The earliest, dating from the 17th century, is an Oriya poem called *Rādhākṛṣṇakeli*, the Sports of Radha and Krishna. The other two, both 18th-century manuscripts in Sanskrit, are episodes from the *Bhāga-vata Purāṇa*, one the *Rāsakrīḍa* section and the other the Tale of Akrura.

The Play of Love from the *Bhāgavata Purāṇa*

This manuscript numbered Or. 11689 comprises the *Rāsakrīḍa* section of the *Bhāgavata Purāṇa*, chapters 29–33 of the tenth canto, in which Krishna satisfies the desires of the women in a mystical com-munal union, which later commentators regarded as a symbol of the soul's longing for, and eventual union with, God. Dating probably from the early 18th century, it consists of 27 palm leaves (each 37 × 4·5 cm), some of which, interestingly, are either preparatory studies for, or rejected versions of, leaves which actually are in the manuscript. It is heavily illustrated, and follows the text minutely and carefully (figs 10–41), including occasionally the Purana's narrators (fig. 19).

The artist's style is in the mainstream of the usual Orissan style of the 18th century, with immensely ponderous limbs, sharply pointed features, and profusion of orna-ments. The architectural details are con-temporary. Unable perhaps to rival the technical mastery of their predecessors in refined and elegant decoration (for which see the next manuscript), the later artists compensated by the addition of sparing touches of colour. This technique degen-erated in the 19th century into a general wash of reds and yellows, of most unpleas-ing effect, but here it is still of considerable beauty. Three of the four coloured leaves illustrate a beautiful episode in the text when the gopis think Krishna has aban-doned them, and they search the forest for Him, calling on the trees and plants by name to say if they have seen Him. Each of the named trees is carefully depicted, in a stylised version of course, but still recog-nisable – the great trees of the forest, the banyan and peepal; the Tulsi, the sacred basil; and a whole variety of flowering and fruiting trees – the mango and breadfruit trees, various jasmines, the Ashoka, etc. (plates IV–VI). All of them are of some religious significance and are described in detail in the Appendix.

The Sport of Radha and Krishna

Consumed with passion Radha arranges a tryst with Krishna, and in a beautiful pa-vilion on the banks of the Jumna her love is consummated. This well-worn story is the theme of the *Rādhākṛṣṇkeli*, an Oriya poem possibly by Balaji Pattanayak. This text is in five fairly brief cantos, in a simple

style, and in its simplicity presumably pre-dates the elaborately artifical type of Oriya poetry introduced by Upendra Bhanja in the early 17th century. The British Library manuscript of this work (Or. 11612) is in 20 folios, almost all of them with incised illustrations on both sides of the leaf (figs. 42–67). It is undated, but on the evidence of the style of the illustrations it must be included in the earliest group of such manuscripts, which may be placed in the 17th century. The presence on two of the folios at beginning and end of the manu-script of a horseman in the Mughal costume of the mid-17th century (fig. 84) prevents us from dating it any earlier. Arguments against a later dating are the elegance of the figure drawing compared with 18th-century manuscripts and the simplicity of the costume, jewellery, hair-styles, etc., which point back, as do the square faces and large almond eyes, to the Bihar bookcovers of 1491 (fig. 8), and to a style which we may assume was current in Orissa also.

This little manuscript (each of whose leaves measures only 24 × 4·5 cm) is most remarkable perhaps for the exquisiteness of its finish and the elegance of its detail, characteristics most in evidence in the woodland scenes on the bank of the Jumna (fig. 43) and in architectural detail. Far from being inhibited by the intractable nature of his medium, this artist has positively revelled in it. At the end, when the poet draws a decent veil over the lovemaking of Radha and Krishna, our artist delights in the possibilities the situa-tion gives rise to, and devotes twelve pictures to ever more ingenious lovemaking positions (figs 62–67).

The Tale of Akrura

The third of these manuscripts is another episode from the tenth canto of the *Bhāgavata Purāṇa*: the *Akrūra Upākhyāna*, or Tale of Akrura, chapters 38–40. Akrura is a kinsman of Kamsa, the wicked king of Mathura, who is trying to kill his nephew Krishna, as it was foretold that the nephew would slay His uncle. Kamsa plans to hold a wrestling contest and to invite Krishna and His brother to it, where they will certainly be killed, and Akrura is to be the messenger. Akrura is divided within himself, as he is a righteous man and already a devotee of Krishna, so he sets out both longing to see the object of his devotions but dreading bringing Him back to Mathura. Krishna however tells him not to worry and on the way back to Mathura in the Jumna river causes Akrura to experience a cosmic vision of Himself and Balarama in Their divine forms as Vishnu and Ananta. Akrura's fears are pacified by this vision and he delivers a great theogony in praise of Krishna as God (figs. 68–82).

This third manuscript (Or. 13719) may also be dated to the 18th century. Each of the 28 palm-leaves measures 22·5 × 4 cm. It is altogether in a lighter style than the *Rāsakrīḍa* manuscript, and in-deed in some of its extravagantly theatri-cal mannerisms seems to be poking fun at the traditional style (see figs. 71 and 73 for examples). The style, however, offers no reference points for outside comparison, other than that technically, in the quality and precision of the draughtsmanship and ornamentation, it is on a lower, and pro-bably later, plane than the *Rādhākṛṣṇakeli*. On the other hand, its extreme angularity links it to the 1499 Bengal book covers, but there is no reason to suppose it to be as early as this. Krishna is rendered dark, alone in this manuscript of the three, in accordance with Hindu tradition. Most interesting in this manuscript are the scenes of the vision of Akrura, which despite their tiny scale, do justice to the cosmic splendour of the vision of God as described in the text (figs. 81–82): the four-armed Vishnu, Preserver of the Universe, with His attributes of Lotus, Conch, Club and Discus, seated on the lap of Ananta the thousand-headed and thousand-hooded cobra (of whom Balarama is an incar-nation), who constitutes the primal matter out of which the universe is periodically created, and who in the intervals between the universe's destruction and its re-creation, serves as the couch on which Vishnu sleeps, floating in the waters of the cosmic ocean.

I. The Play of Love (Or. 11689)

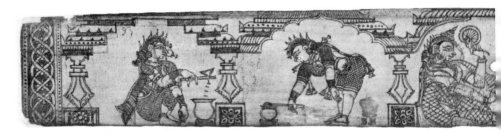

10. It is evening in Brindaban, and the women are going about their domestic tasks – milking the cows and preparing the food (colour plate III).
As good and dutiful wives they are cooking and serving their husbands the evening meal,

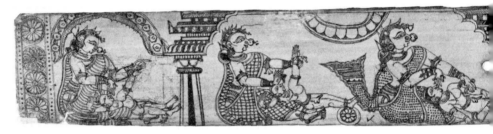

11. playing with their children and feeding them

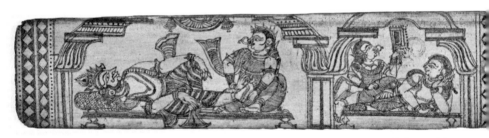

12. tending to their husbands' wants by massaging their feet and fanning them, and then retiring for their own meal;

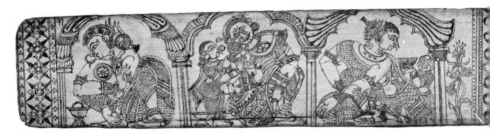

13. other women are engaged in their toilette, anointing themselves with perfume or massaging their limbs, or applying collyrium to their eyes, when through the soft evening air steals the music of Krishna's flute, and abandoning their tasks the women start up to go to Him.

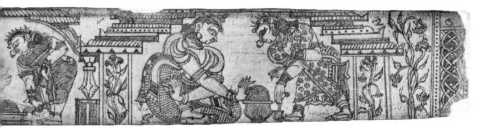

10. f. 2a

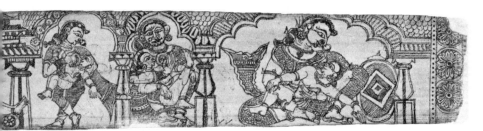

11. f. 2b

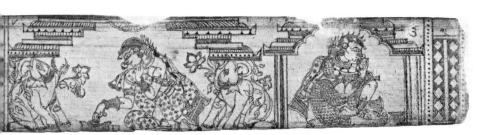

12. f. 3a

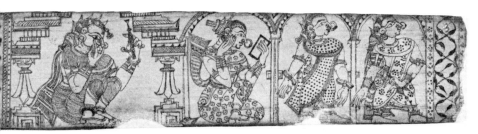

13. f. 3b

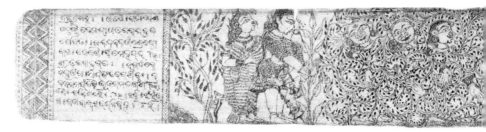

14. *The forest is aflame with flowers bathed in moonlight, gently stirred by the breeze from the Jumna. The women make their way through the forest to the bower where Krishna awaits them.*

15. f. 5b

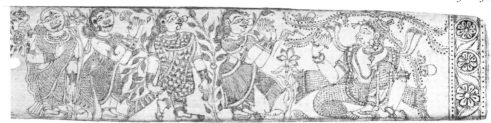

15. *'Why have you come?' Krishna asks them, 'What has brought you out into the dangerous night? Your husbands and parents will be missing you; your children need feeding, your cows milking. It is perhaps through love of Me that you come? But a wife's supreme duty is to her husband. To have a lover is repugnant for a noble woman. It is through thinking of Me that you show your love, not through seeking Me out – return to your homes!'*

18. *Krishna takes pity on the women's grief, and smiles on them. He leads them through the forest while they sing His praises.*

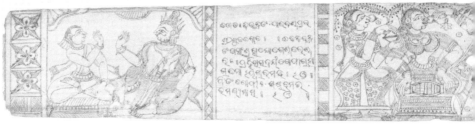

19. *On an island in the river He begins to dance with them to the music of drums and cymbals.*

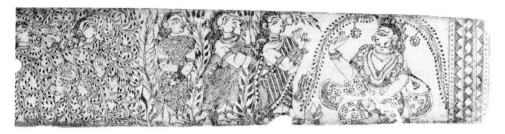

14. f. 4b

16. f. 6a 17. f. 6b

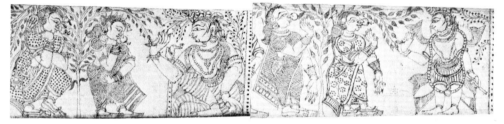

16. *At these harsh words, the women abandon themselves to tears. 'We have abandoned everything for love of You, Lord. The duty of women is to their masters; but to whom should we pay our duty, if not to You, the Lord of all?'*

17. *'Who is of any importance to us compared to You? What could we do of any use when far from You? Take pity on the pangs of our love caused by Your smile, Your glances, the melody of Your flute; allow us but to be Your slaves, to worship the dust of Your feet.'*

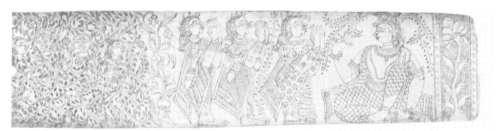

18. f. 7b

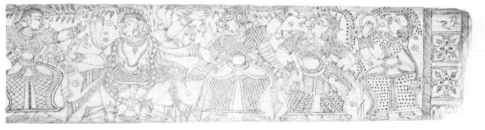

19. f. 8a

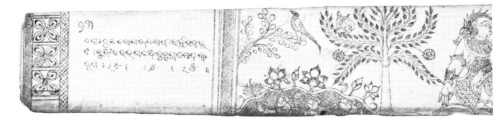

20. *They enjoy the breeze which ruffles the river and spreads the lotuses' scent.*

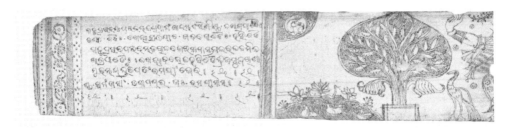

21. *He dances with them, caressing and stroking them, leaving the marks of His nails all over their bodies,*

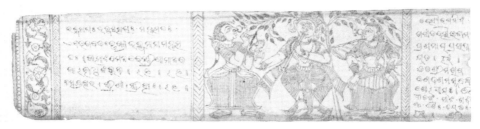

22. *working them up into a frenzy of passion through His flute, so that they believe themselves above all women, and then:*
seeing the effect His beauty is having on them, He suddenly vanishes so that they can return to calmness again.
The women are left desolate by Krishna's disappearance, and wander through the forest searching for Him. They enquire of the plants and trees whether they have seen Krishna pass by:
'O Ashvattha, Plaksha, Nyagrodha! have you seen pass by Krishna, Who has stolen our love by His smiles and glances of love?
'O Kuruvaka, Ashoka, Naga, Punnaga, Champaka! has Krishna gone by, through Whose smile proud women are humbled? (plate IV)
'O Tulsi! have you seen Krishna, your beloved, Whom you deck with swarms of bees?
'O Malati, Mallika, Jati, Yuthika! have you seen Krishna, the touch of Whose hand gives joy? O Cuta, Priyala, (plate V)
'Panasa, Asana, Kovidara, Jambu, Arka, Bilva, Amra, Kadamba, Nipa, and all you who dwell by the Jumna, tell us where Krishna went when He disappeared!
'O Earth! does your hair stand on end for joy at the touch of Krishna's feet? (plate VI)

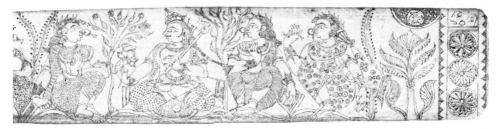

20. f. 9a

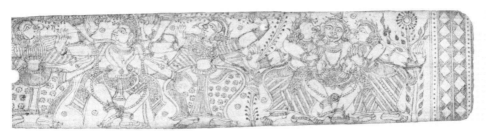

21. f. 9b

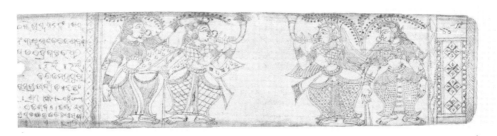

22. f. 10a

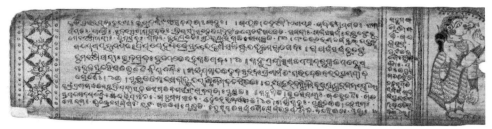

23. 'O Deer! did Krishna pass you by, delighting you with His beauty?'

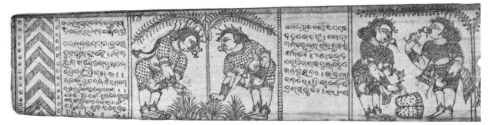

24. Calling thus to the trees and animals they wander distractedly through the forest, when suddenly they come upon Krishna's footprints and side by side with His those of a damsel. 'Who is she, this lady who has taken Krishna from us to enjoy Him alone?' they cry grief-stricken. 'Here He must have carried her through the coarse grass to protect her feet! Look at these deep footprints where He carried her! Here He set her down and then stood on tip-toe to gather flowers, and here He must have sat to adorn her braid with them!'

25. f. 14b

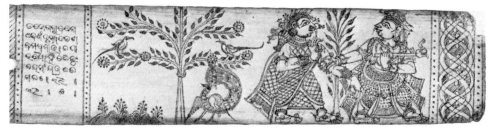

25. That damsel who was singled out by Krishna thought herself the most blest of women as He led her through the forest.

27. f. 15a

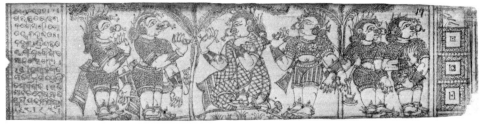

27. Her wandering friends find her, and she tells them how Krishna favoured her and how she lost Him; they begin to retrace their steps –

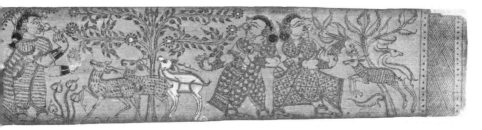

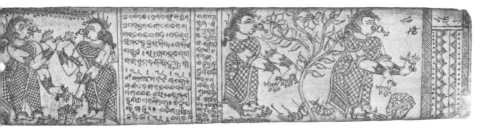

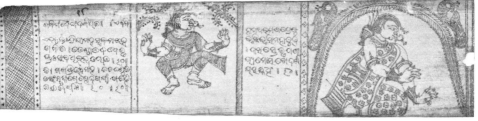

5. *Full of pride, she said 'I can walk no further, please carry me!' Mounted on Krishna's
shoulders, He vanished from beneath her, leaving her to grieve, disconsolate.*

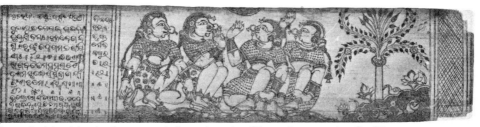

8. *to the island in the Jumna, and there they sing His praise, yearning for His return.*

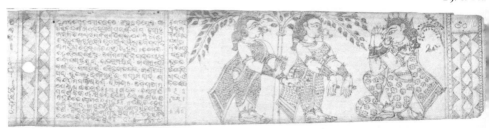

29. 'O Krishna, O Protector! O God Who knows the hearts of all, Who has been born to save the world! Return to us Your hand-maidens.

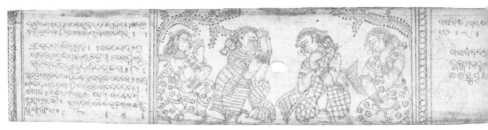

30. 'Put Your lotus-feet on our breasts to cure our heart's affliction! Comfort us who swoon for You with Your sweet voice! Delight us with Your lotus-face amidst dark curls, let us taste the nectar of Your lips. Show us Your body for which we long. Return to us!'

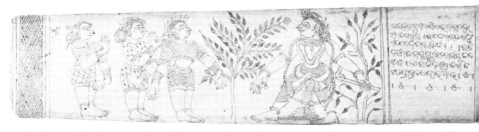

31. Krishna suddenly shows Himself again to the wailing women, who stand up to drink in His beauty like limbs returned to life by air.

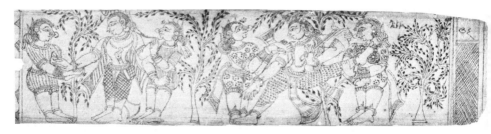

Joyfully, one places His hand between her palms, another puts His arm round her shoulder; a third cups her hands to receive His chewed betel; a fourth rests His foot on her bosom.

24 KRISHNA: A HINDU VISION OF GOD

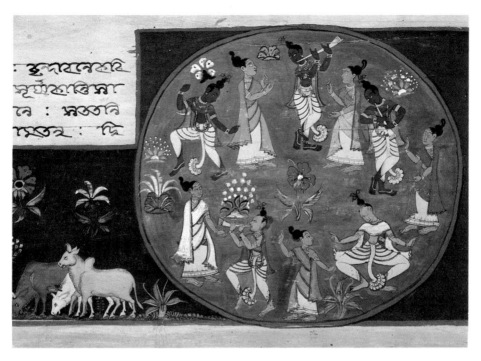

I. *The* Rāsamaṇḍala (*Circle of Love*): *Krishna dances with each of the gopis, Assam. 1836–7. Or. 11387, f. 142b* (detail) (*24·5 × 64·5 cm, complete*)

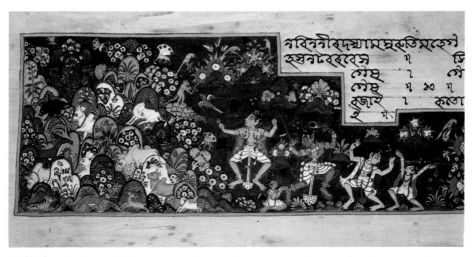

II. *Krishna sporting with the cowherds. Assam, 1836–7. Or. 11387, f. 3a* (detail) (*24·5 × 64·5 cm, complete*)

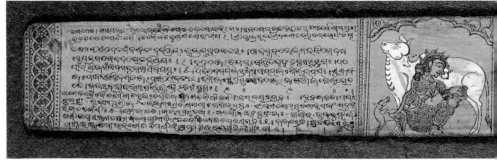

III. *Or. 11689, f. 1b.*

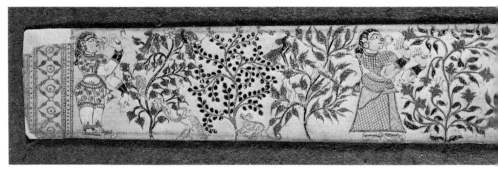

IV. *Or. 11689, f. 12a.*

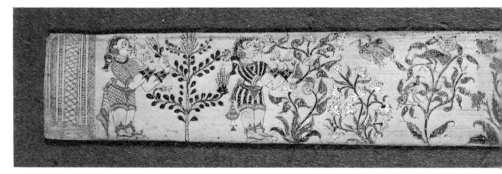

V. *Or 11689, f. 12b.*

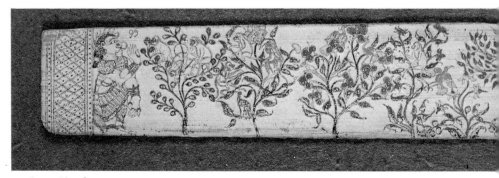

VI. *Or. 11689, f. 13a*

26 KRISHNA: A HINDU VISION OF GOD

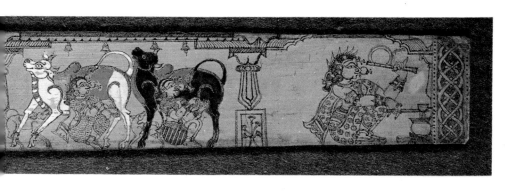

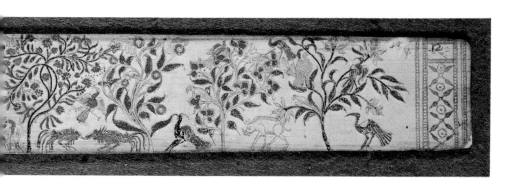

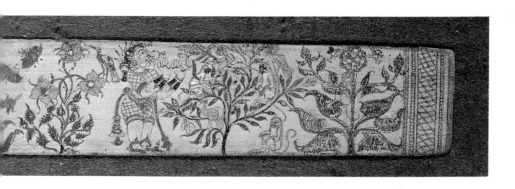

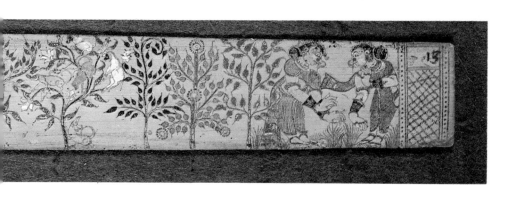

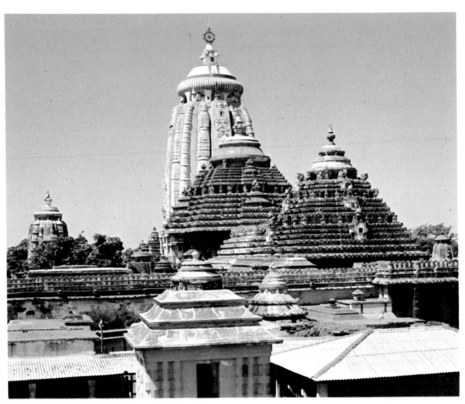

VII. *The temple of Jagannatha at Puri, Orissa, begun* ca. *1135.* (*Photo: author*)

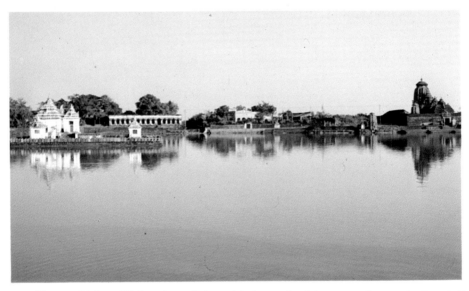

VIII. *The sacred lake at Bhubaneshwar, Orissa, with the temple of Anantavasudeva on the shore, built in 1278. This is the only Vishnu temple in Bhubaneshwar.* (*Photo: author*)

32. One bites her lips and knits her brows and glares as if to strike Him. Two others gaze at Him, one with unwinking eyes, the other's half-closed.

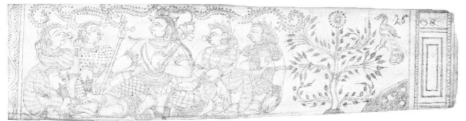

33. On the sands by the Jumna's shore they make a seat for Him of their garments, and seated on it they caress His hands and feet.

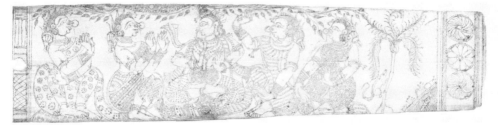

34. The women question Krishna: 'Why do You appear not to love us despite our great love for You?' He replies: 'I do not respond to those who devote themselves wholeheartedly to Me, so as not to interrupt their devotions.

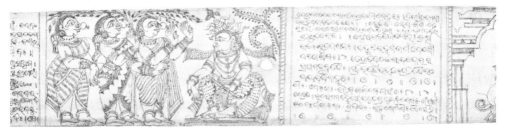

35. 'For Me you have renounced the world, my beloveds, the Vedas and your homes – I have been with you invisibly to see the extent of your devotion to Me. Were I to make you celestial nymphs I cannot sufficiently reward your devotion to Me, you who have broken your domestic ties for Me. May your meritorious conduct be its own reward!'

KRISHNA: A HINDU VISION OF GOD 29

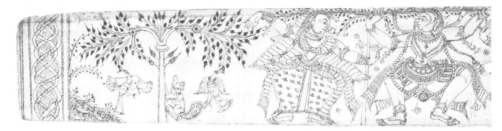

36. Then Krishna begins to dance with the women who form a circle hand in hand.

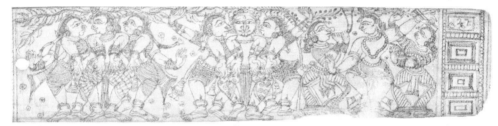

37. Through His divine power, He enters in between each pair of dancers, His hands about their necks, and dances amidst the flowers let fall from heaven by the assembled gods.

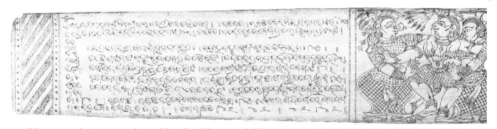

39. They rest their arms about His shoulders, and He supports them; they kiss His hands and press them to their heated bosoms.

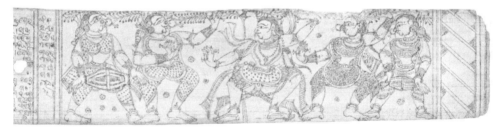

40. Their dancing becomes wilder and wilder as their senses are overwhelmed at the Lord's embraces, while He, though finding delight only in Himself, sports with them.

41. Wearied and sweating, the dancers are finally led by Krishna into the cool waters of the Jumna; thence He leads them back to the groves where He sports with them as a rutting elephant with his mates.

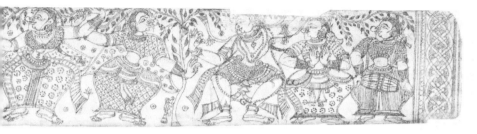

36. f. 22b

38. f. 23b

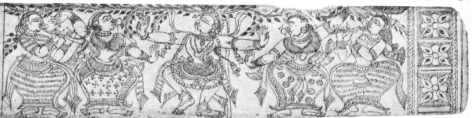

Transported with happiness, the dancers praise Krishna, becoming more and more fatigued.

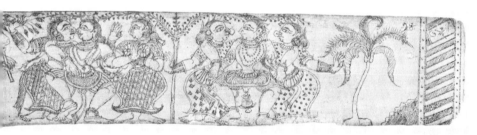

39. f. 24a

41. f. 25a

u ask how God who is the embodied Law can thus flout the law in respect of married
en, it is because as the Supreme Lord and ruler of all He has passed beyond the
sites of good and evil, and lacking an ego has naught to gain through doing the one and
he other. The women's husbands had no fault to find, for they, through His power, thought
wives were by their side. And at the dawn, the women did reluctantly at the Lord's
ng return to their homes.

II. The Sport of Radha and Krishna (Or. 11612)

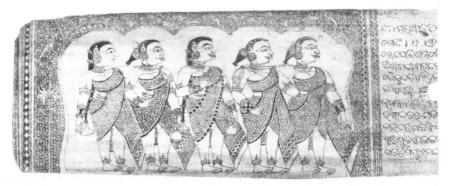

42. The season of Spring has come to the forests of Brindaban, and everywhere the trees are in flower; Radha and her companions wander through the groves admiring the blossoms and seeing the effect of the season on the dancing peacocks.

43. The river Jumna which flows by the groves of Brindaban is full of geese eating the tender new shoots of the lotuses; on the bank is a delightful bower amid the creepers and blossoming trees, full of the sounds of cuckoos and humming bees.

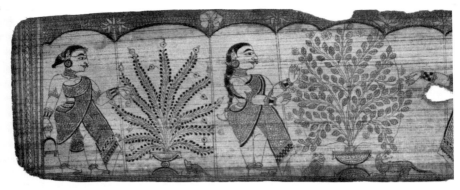

44. Everywhere are new and tender sights and scents to delight the eye and nose; tender blossoms of campa, nagesvara, jati, yuti and mallika are admired by the women.

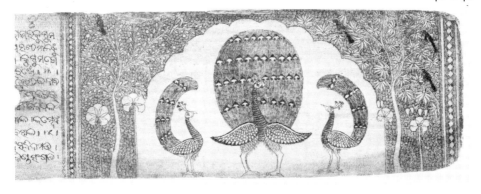

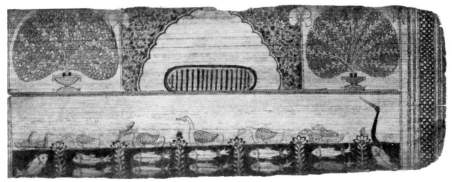

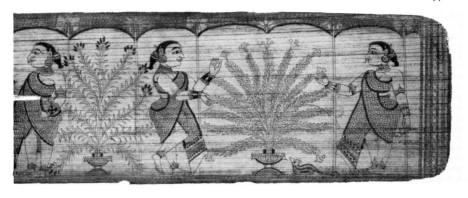

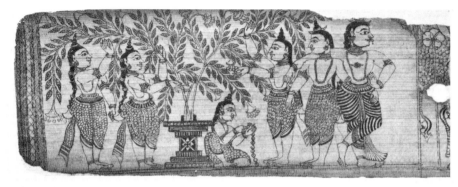

45. *Suddenly Radha and her friends come upon a group of young men tending a sacred basil tree, among whom is the beautiful Krishna. Radha and Krishna stare transfixed at one another, as the arrows of the god of love shoot between them.*

46. f. 7b

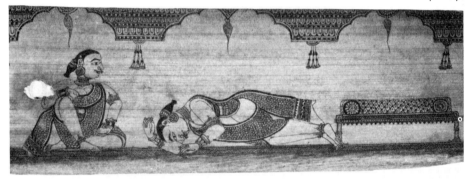

46. *Afire with her passion, Radha returns home, and confesses her torment to her friend.*

48. f. 8b

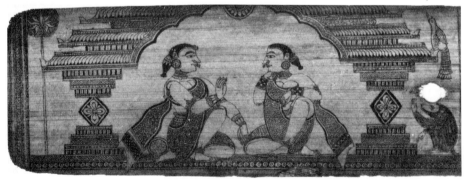

48. *She is consumed with passion for Him, and cannot bear to be without Him. Radha begs her friend to act as go-between for them.*

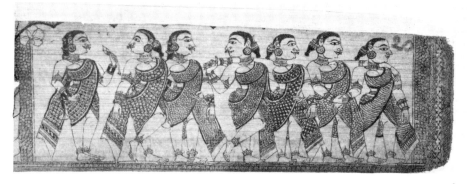

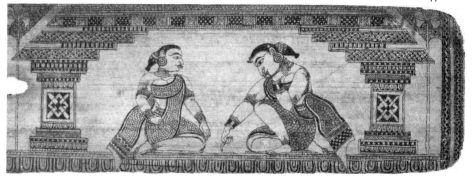

47. She describes Krishna's wondrous beauty, dark as a blue lotus or a sapphire, His marvellous body with the beautiful curl on His chest.

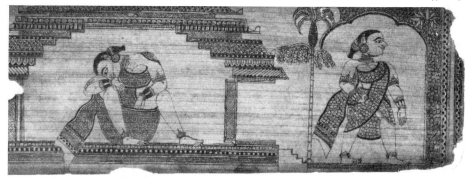

49. The friend agrees, and leaving Radha sunk in her longing, sets off for the Brindaban forest.

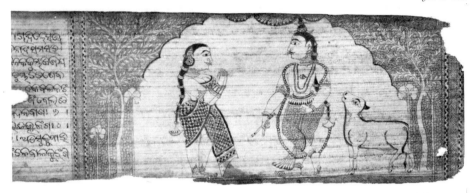

50. In the groves she meets Krishna who is tending the cattle, and tells Him of Radha's passion and begs for a meeting.

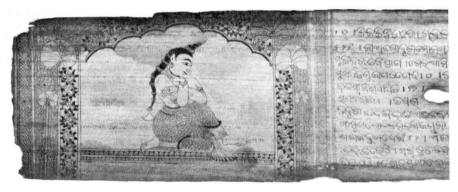

52. Leaving Krishna sunk in thought and anticipation, the go-between makes her way back through the forest.

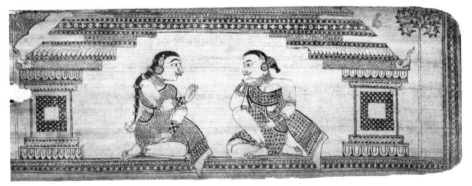

53. Radha joyfully hears the success of her mission,

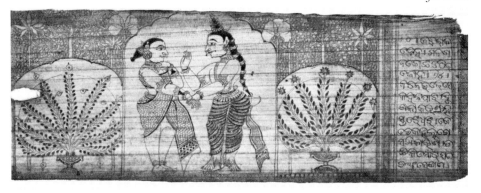

51. Krishna assents, and they fix on a time and place.

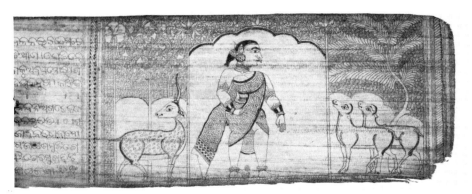

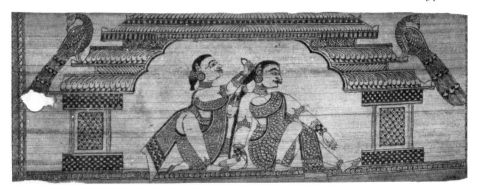

54. and she begins to prepare for her tryst. Her hair is dressed,

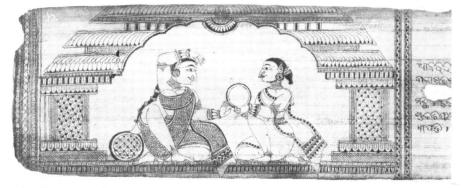

55. the tika spot applied to her forehead, and her ornaments put on.

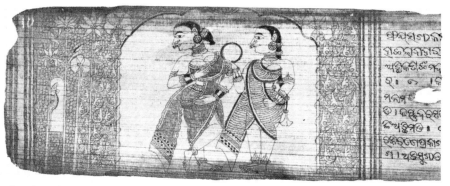

56. One last check, and then the two set off for the tryst.

57. It is a beautiful night of the full moon as they approach the groves of Brindaban,

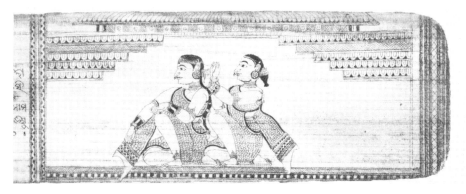

55. f. 13a

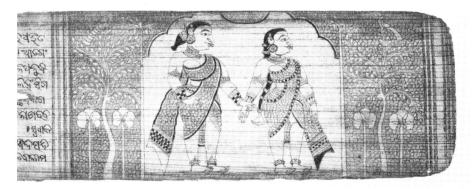

56. f. 14a

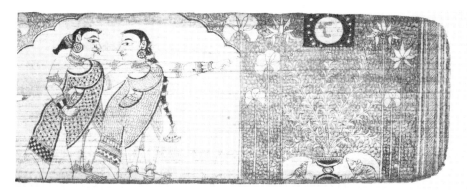

57. f. 14b

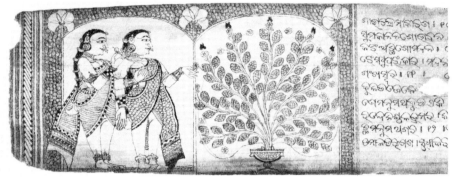

58. and enter into the forest lit by the moon's rays.

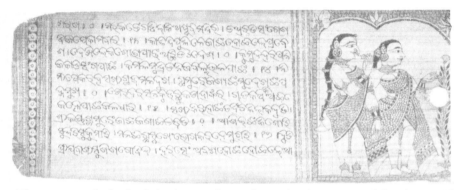

59. They come to the bank of the Jumna where a bower has been prepared for them amid fragrant trees,

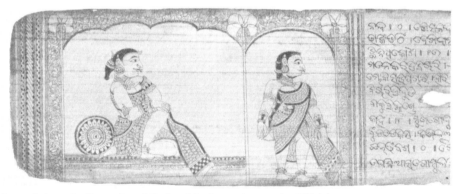

60. and there Radha waits while her friend goes in search of Krishna.

58. f. 15a

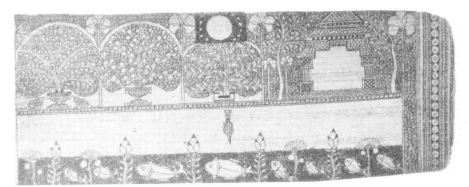

59. f. 15b

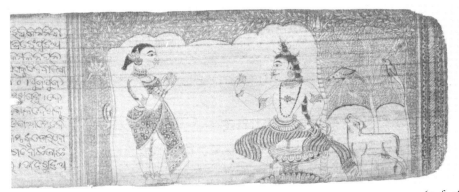

60. f. 16a

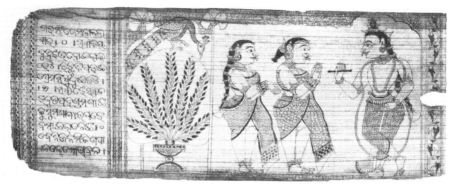

61. Krishna and Radha are finally brought together and Radha's friend leaves them,

62. and they consummate their love.

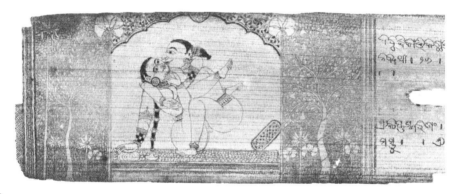

63.

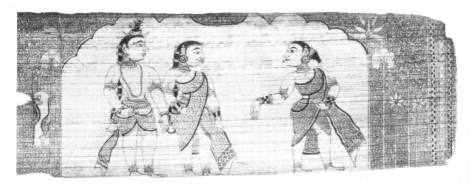

61. f. 17a

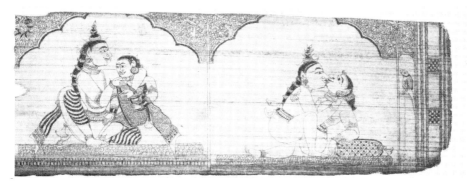

62. f. 17b

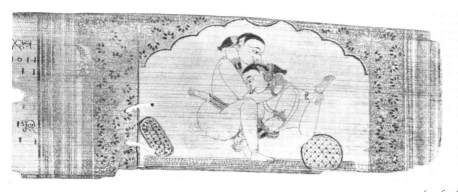

63. f. 18a

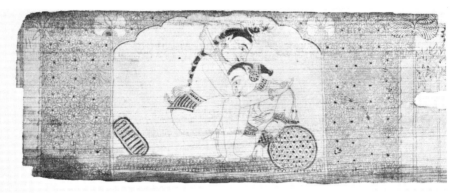

64.

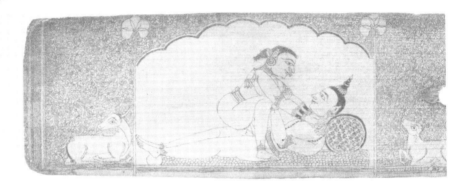

65.

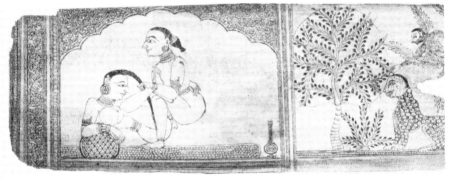

66.

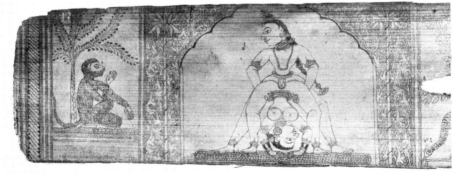

67.

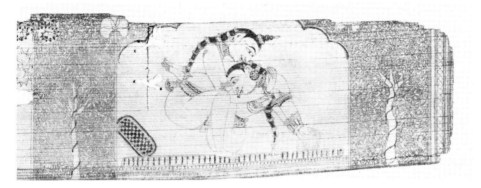

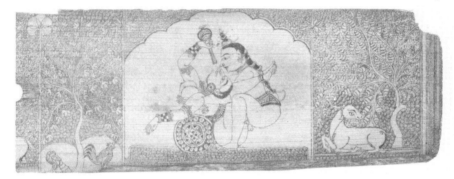

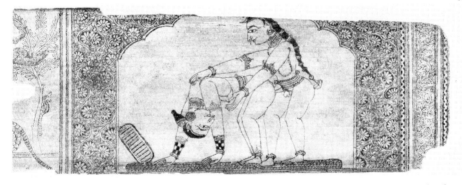

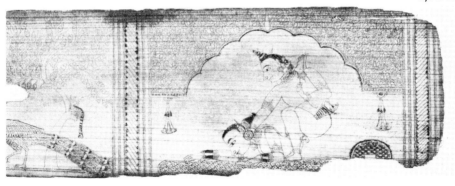

KRISHNA: A HINDU VISION OF GOD **45**

III. The Tale of Akrura (Or. 13719)

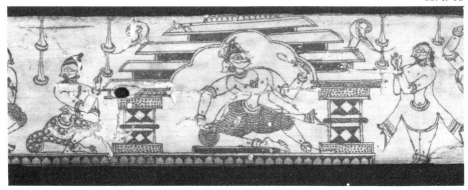

68. The wicked Kamsa, king of Mathura and uncle of Krishna, orders Akrura to go to Brindaban to bring Krishna and Balarama to Mathura to a great feast, at which he plans to kill Them.

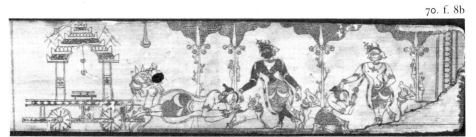

70. Akrura falls prostrate like a pole at the feet of the two boys who adorn the forest with Their beauty, speechless with the fullness of his emotions at seeing the object of his worship.

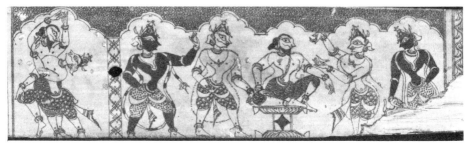

72. Balarama also embraces him, and then, having gone to the house, Akrura is seated in the place of honour, asked about his journey, and made the usual offerings to a guest; and then he relates why he has come at Kamsa's bidding. Krishna and Balarama laughingly agree to go with him,

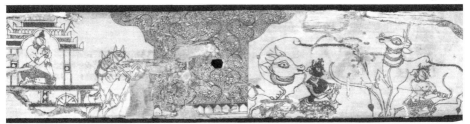

*69. Akrura drives in his chariot to Brindaban, rejoicing in his good fortune that he is to see the
Supreme Lord, Who he hopes will receive him despite his being a messenger of Kamsa.
He arrives at Brindaban and comes upon Krishna and Balarama milking cows.*

71. f. 9a

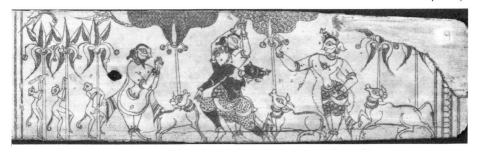

71. But Krishna understands his heart, and draws him up to embrace him.

73. f. 13a

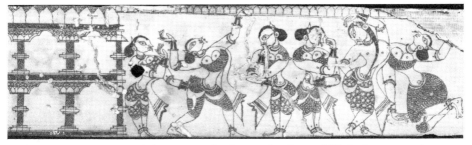

*73. but the women of Brindaban are sorely distressed to hear of Their departure; they meet
together to mourn.*

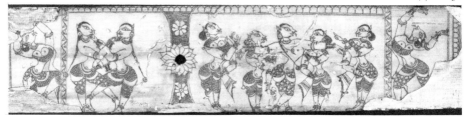

74. *The women give vent to their grief, blaming Akrura for taking their beloved from them, and lamenting the good fortune of the women of Mathura who will be blessed with the sight of Krishna.*

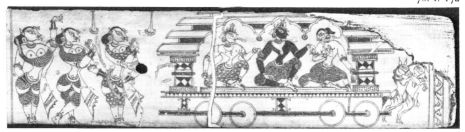

76. *and try to stop Them with their lamentations.*

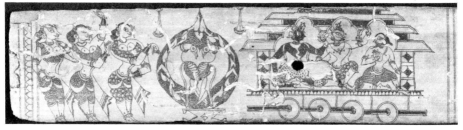

78. *Seeing how distraught the women are, Krishna tells them that He will send messages to them and that He will return to them.*

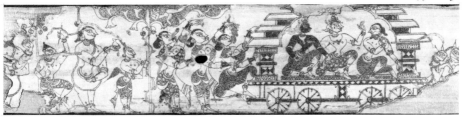

75. *They hasten to Akrura's chariot for they see Krishna and Balarama within it about to depart,*

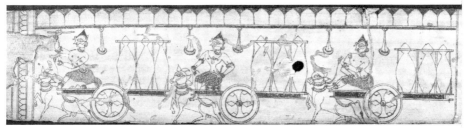

77. *The cowherds come up with their chariots full of presents, of churns of milk, butter and curds.*

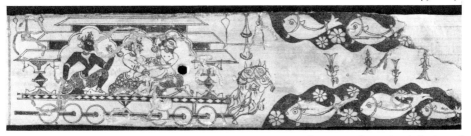

79. *Swiftly the chariot comes to the Jumna, and Akrura resolves to make a ritual sipping of its pure water.*

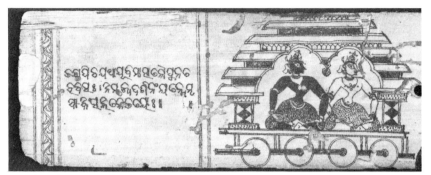

80. Leaving the other two in the chariot, he enters the water. But there too in the water he sees the selfsame chariot with Krishna and Balarama inside it, and looking at the bank he sees Them again.

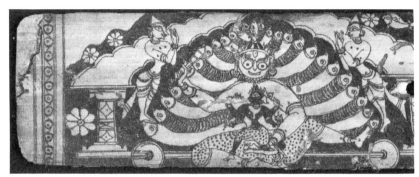

81. And looking again in the river he sees that in the chariot is the mighty serpent Ananta with his thousand heads and thousand hoods and on his lap is seated Vishnu, with His four arms carrying His attributes, and with His divine beauty enhanced by his ornaments.

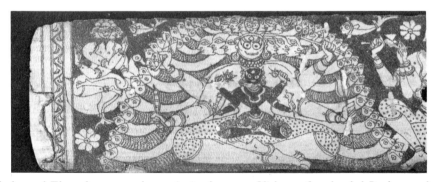

82. And round Them the great gods are singing hymns to Vishnu – four-headed Brahma and trident-bearing Shiva with his bull, and the beautiful Lakshmi, and Indra on his elephant. And seeing that Krishna was vouchsafing him this revelation of His supreme divinity, Akrura begins a song of praise, in worship of the Supreme Lord: 'Hail to Thee, the cause of all causes, changeless and unending, through Whose agents the world is created, Who art the ultimate object of all worship, for just as rivers, rain-swelled from mountains, all find their way to the ocean, so all worship finally finds its way to Thee. Hail to Thee who comest into the world ten times to rid it of its grief! I being ignorant, helplessly urged hither and thither by my ego and senses, approach Thy feet – have mercy and protect me!'

80. f. 20b

81. f. 21b

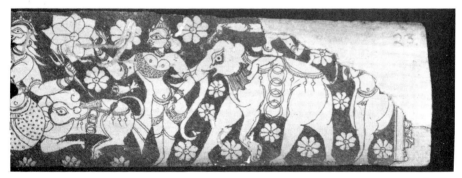

82. f. 23a

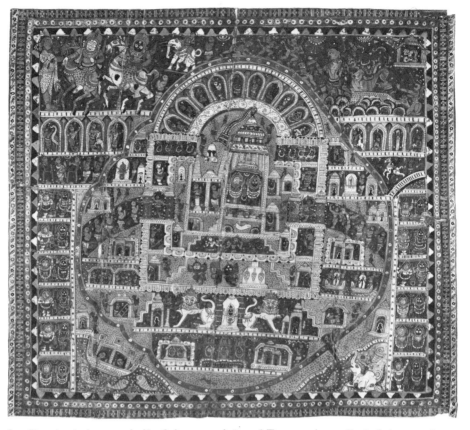

83. Paṭa (*paintings on cloth*) *of the great shrine of Tagannatha at Puri. Orissa, 19th cent. Or. 13938. (59 × 67 cm)*

Paṭas *were produced in large numbers as mementoes for pilgrims to take away from Puri, and show the sacred geography of the town. In the centre are the cult images of Jagannatha, with his brother Balarama and sister Subhadra, installed in the great temple with its surrounding wall, while within the town wall are representations of other important shrines and cult images, mostly Shaiva. Surrounding the whole are representations of the avatars of Vishnu, of episodes from the life of Rama and that of Krishna, and of the various iconographic representations of the chief deities of Puri.*